Pow Wow
Coloring Book

Volume II

By

PowWows.com

POW WOW Coloring Book Volume II

By Powwows.com

ISBN-13: 978-0-692-83346-9

What is a Pow Wow

Pow Wows are the Native American people's way of celebrating by meeting together in dances and songs. This is a time for visiting and renewing old friendships, and making new ones. Pow Wows help renew the Native American culture and preserve the rich heritage of American Indians. Pow Wows are celebrations held annually throughout North America.

Visitors can enjoy the culture of various tribes by seeing the dancing and singing, trying Native food, or shopping for authentic crafts. Pow Wows are open to the public and welcome spectators.

Read more - http://www.powwows.com/what-is-a-pow-wow/

Find a Pow Wow near you - http://www.powwows.com/calendar

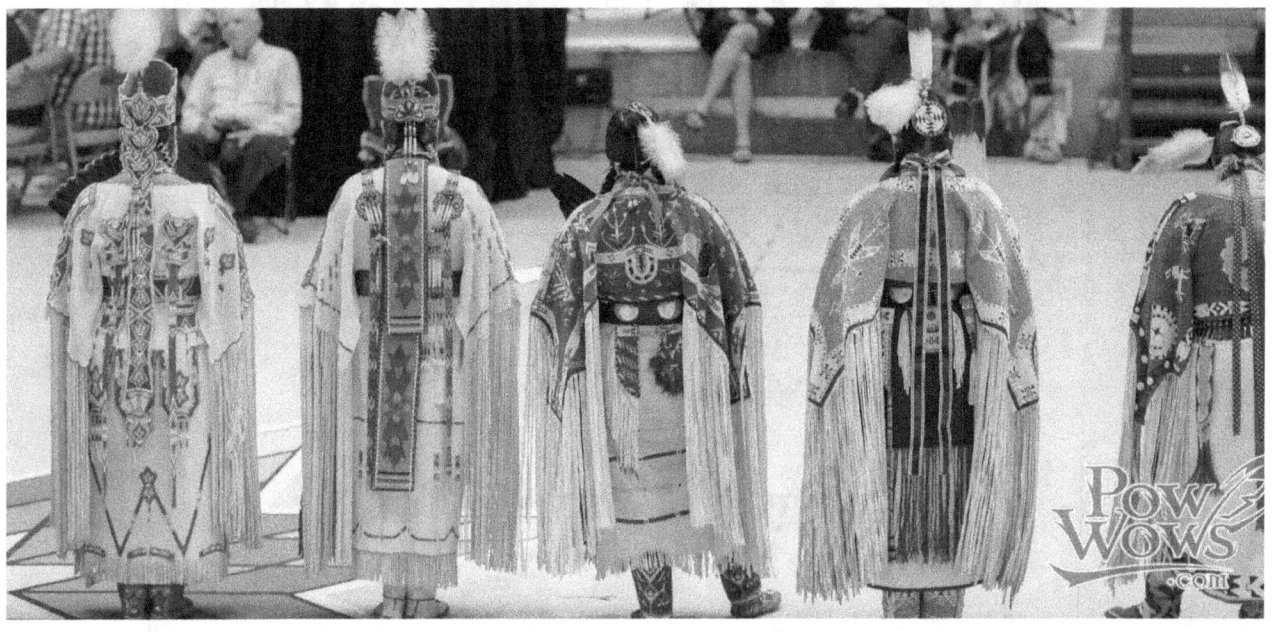

About PowWows.com

PowWows.com is your online portal for Native culture since 1996. Our goal is to share Native American culture with the world. Explore the rich culture through our photos, videos, calendar, articles and more.

Follow PowWows.com

Facebook - http://www.facebook.com/powwowscom

Instagram - https://instagram.com/powwowscom/

Twitter - http://www.twitter.com/powwows/

Youtube - https://www.youtube.com/user/PowWowsCom

Pinterest - http://pinterest.com/powwowscom/

Share your finished pages with PowWows.com!

Instagram - #pwcoloringbook
Twitter - #pwcoloringbook

Upload to PowWows.com

www.powwows.com/pwcoloringbook

Submit a design for our next coloring book!

www.powwows.com/submitdesign

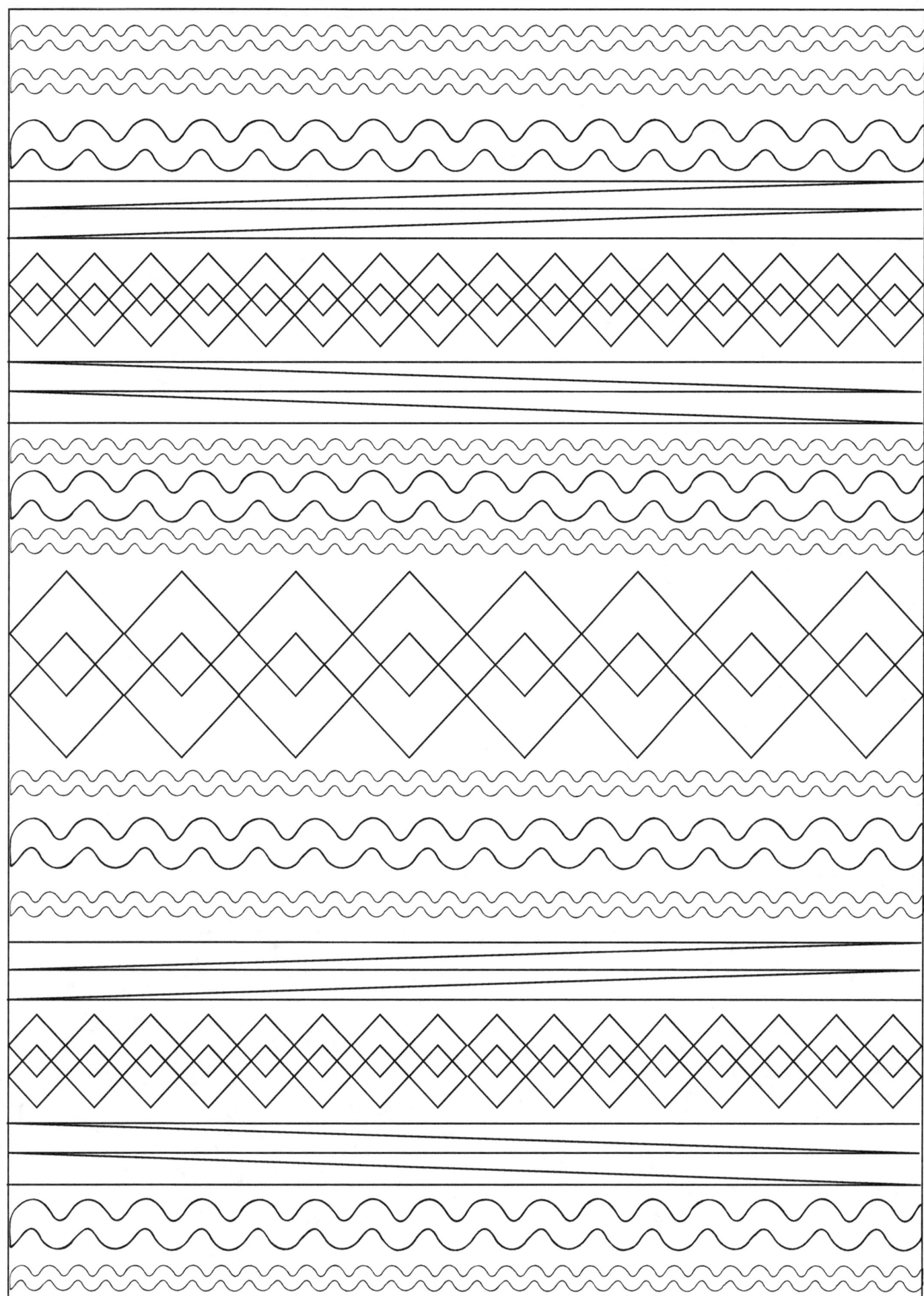

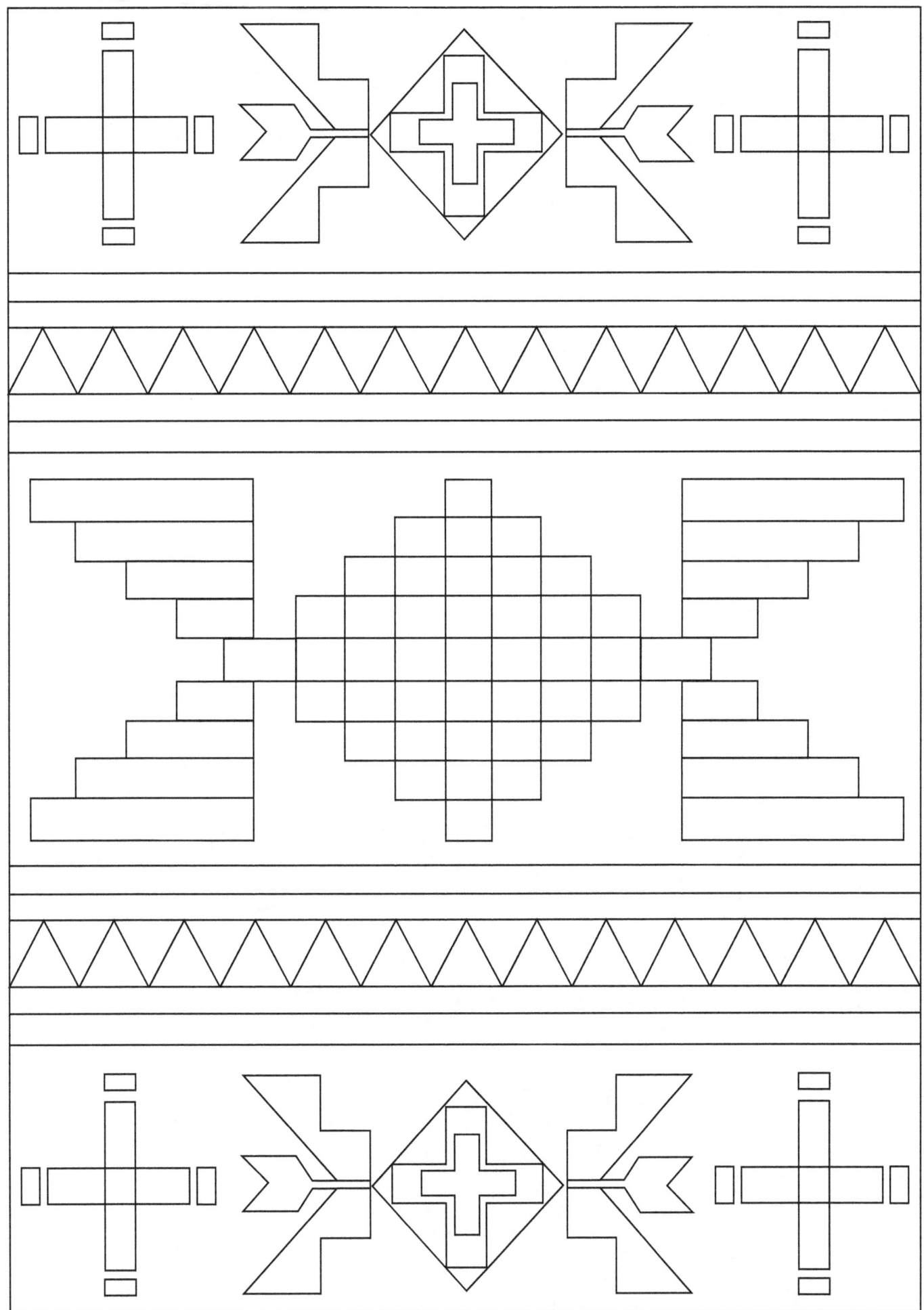

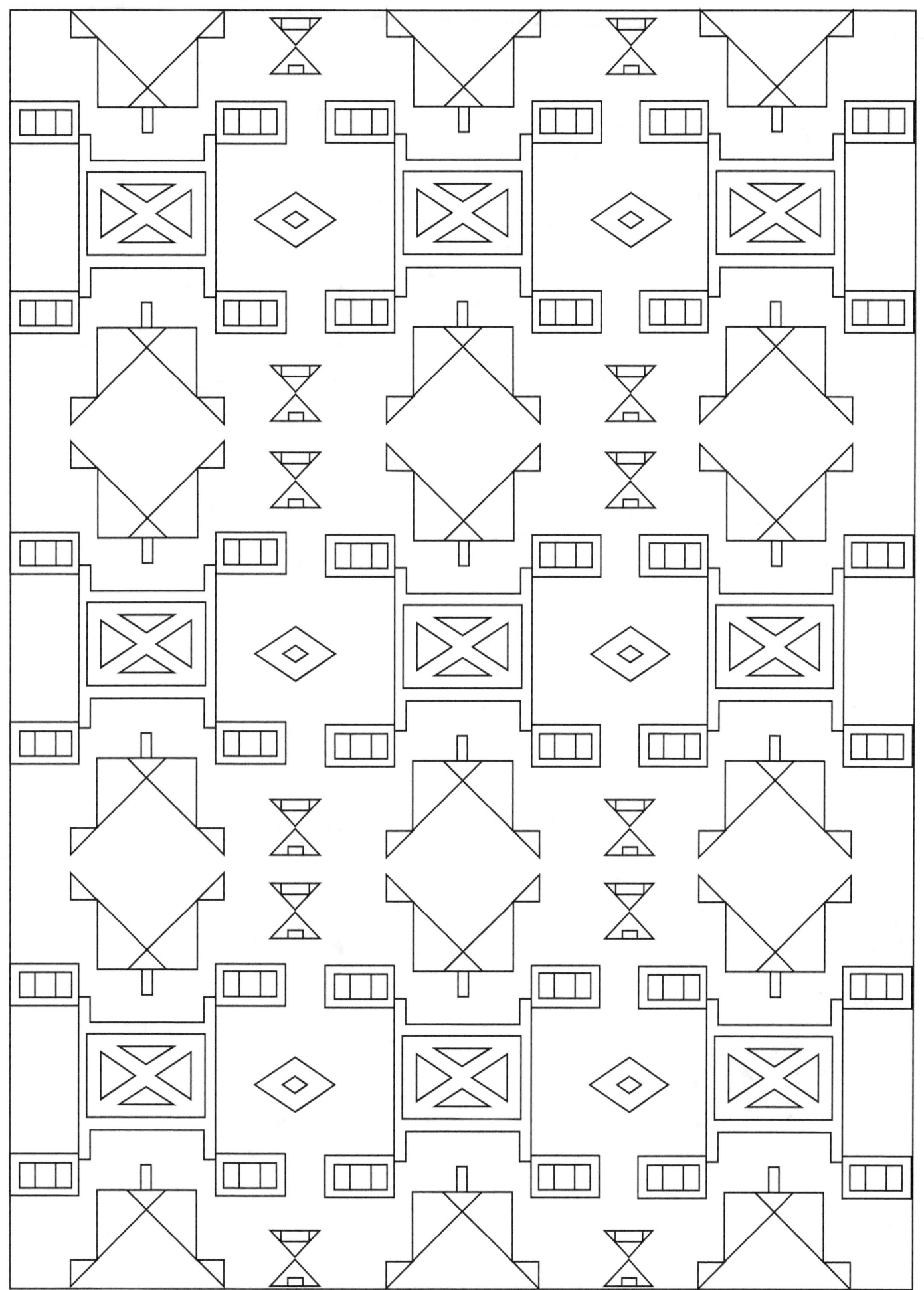

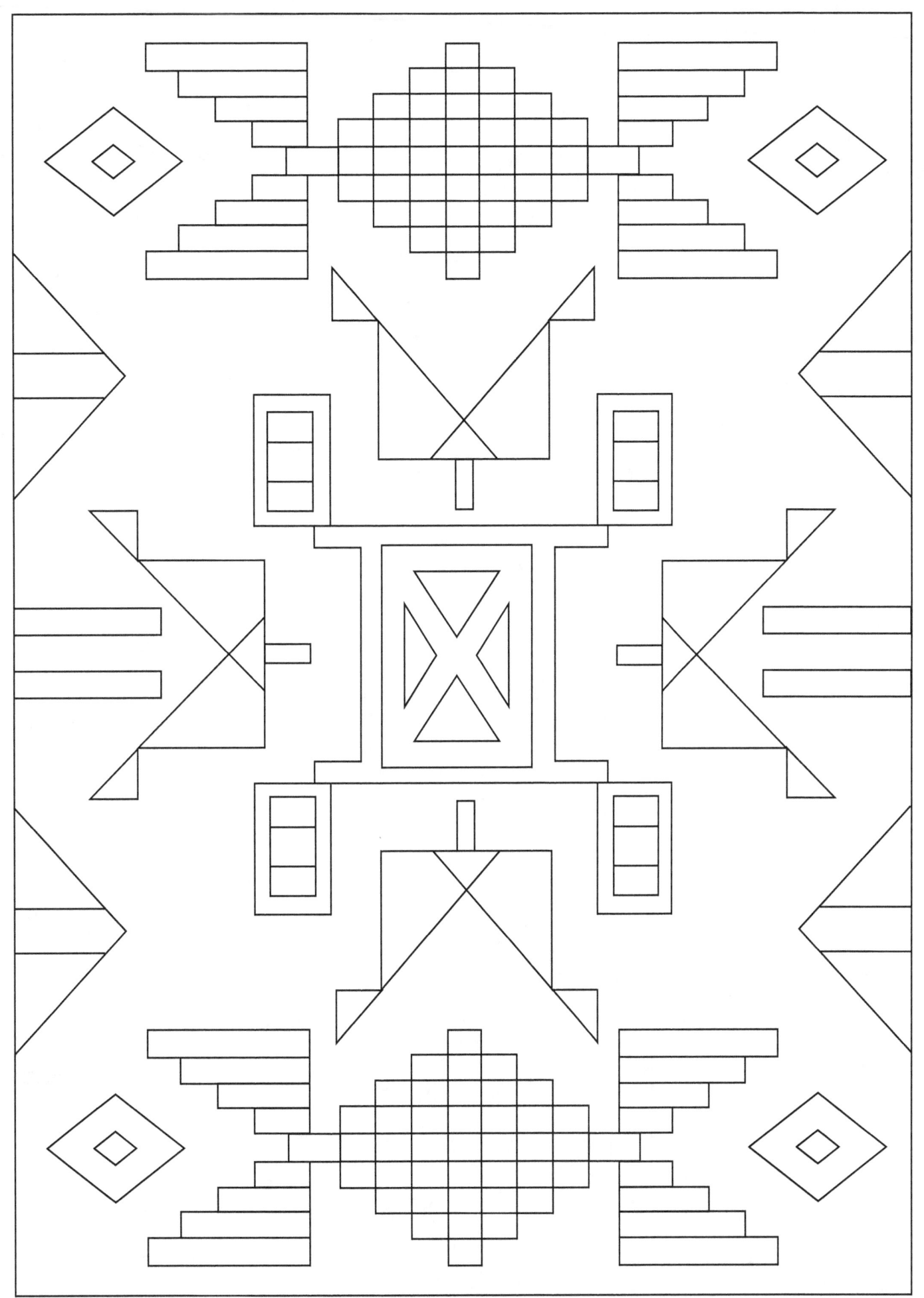

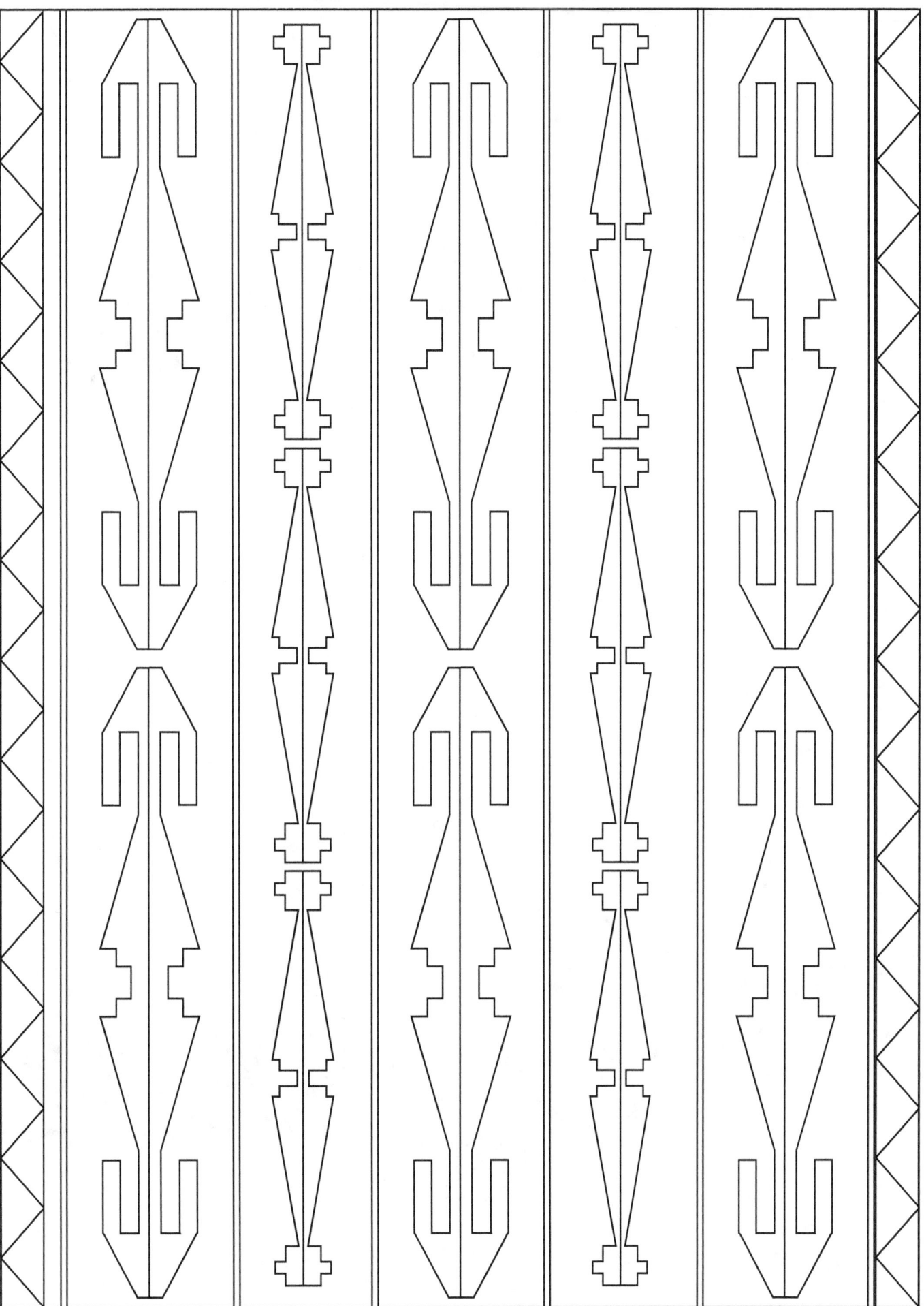

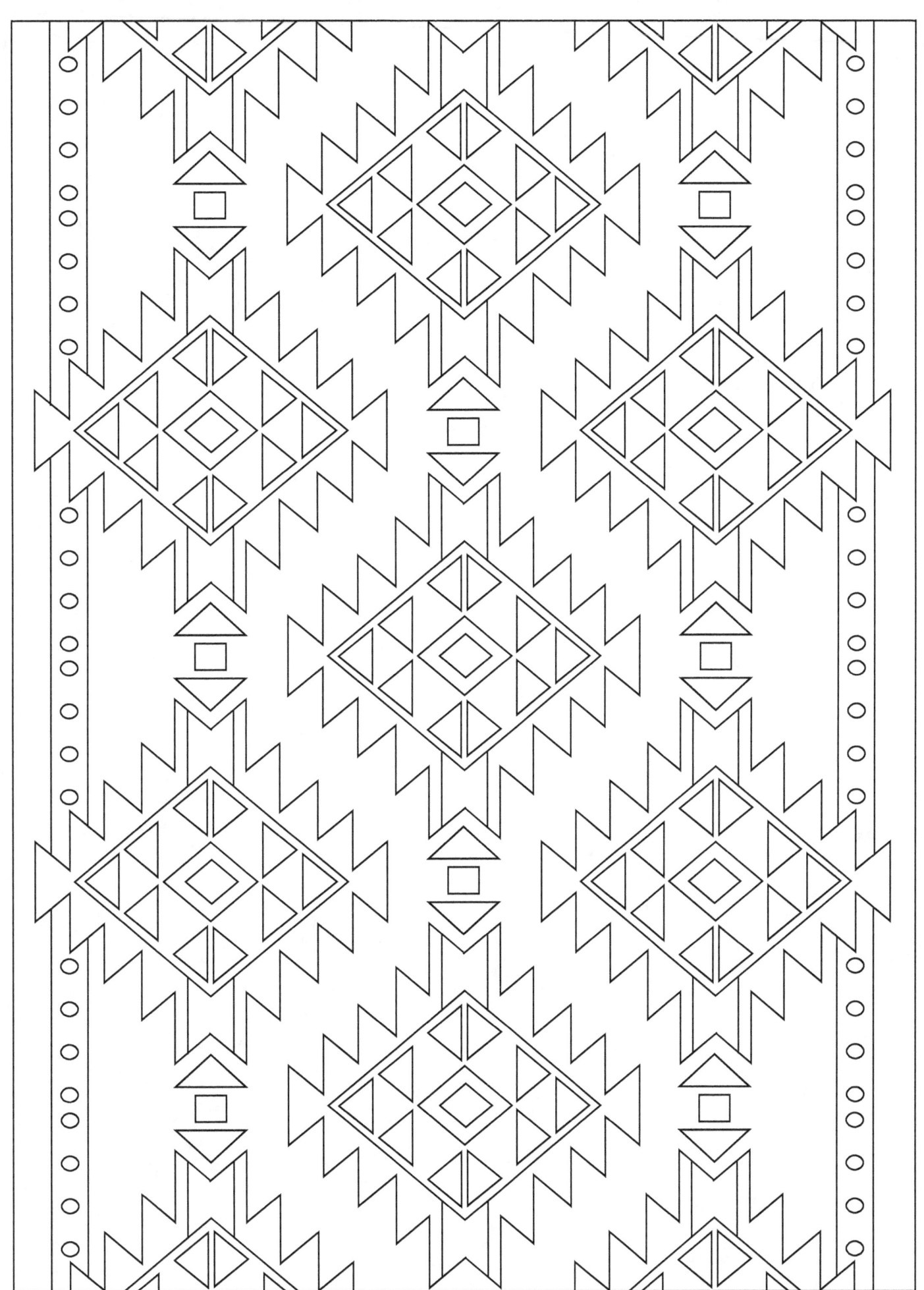

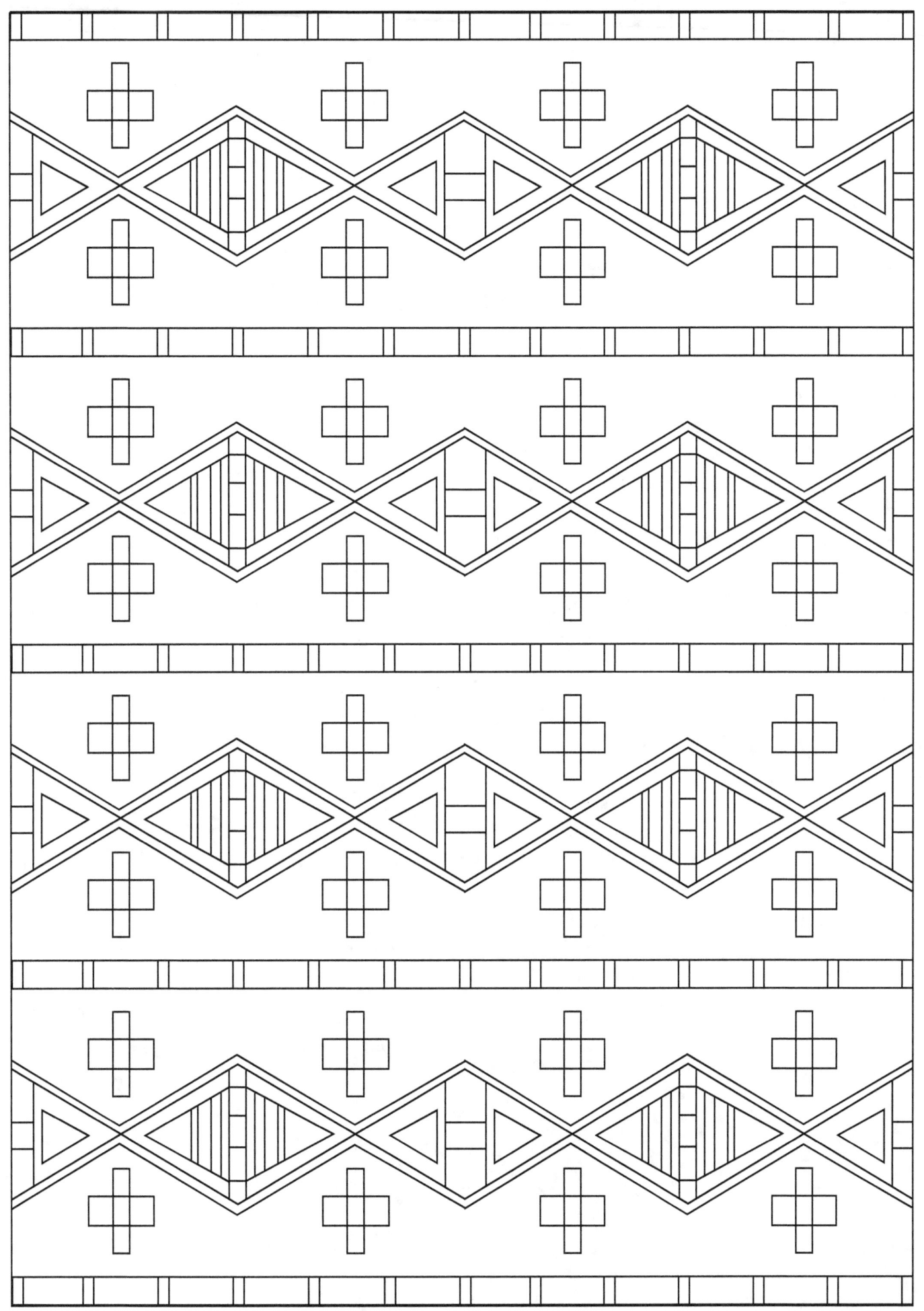

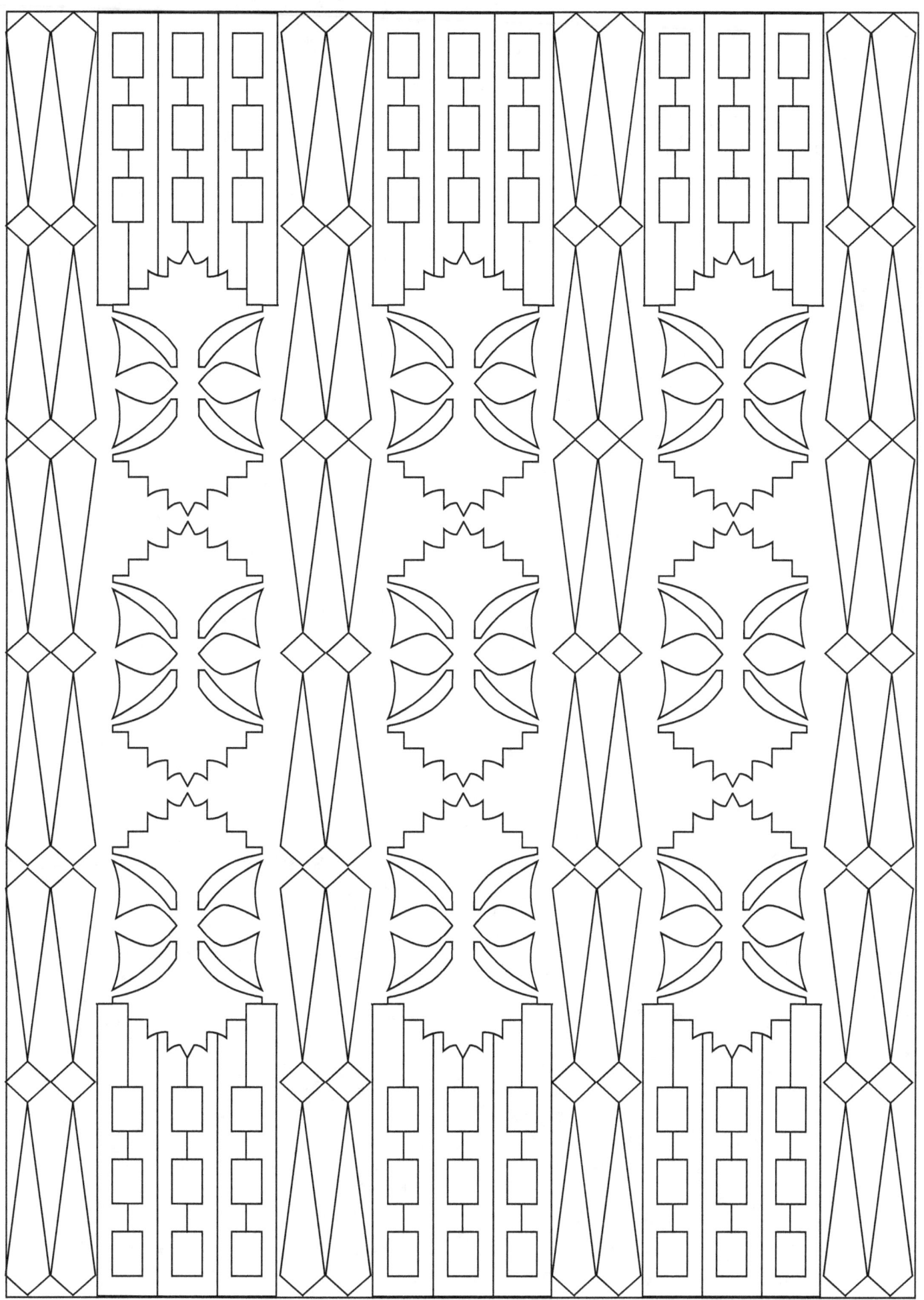

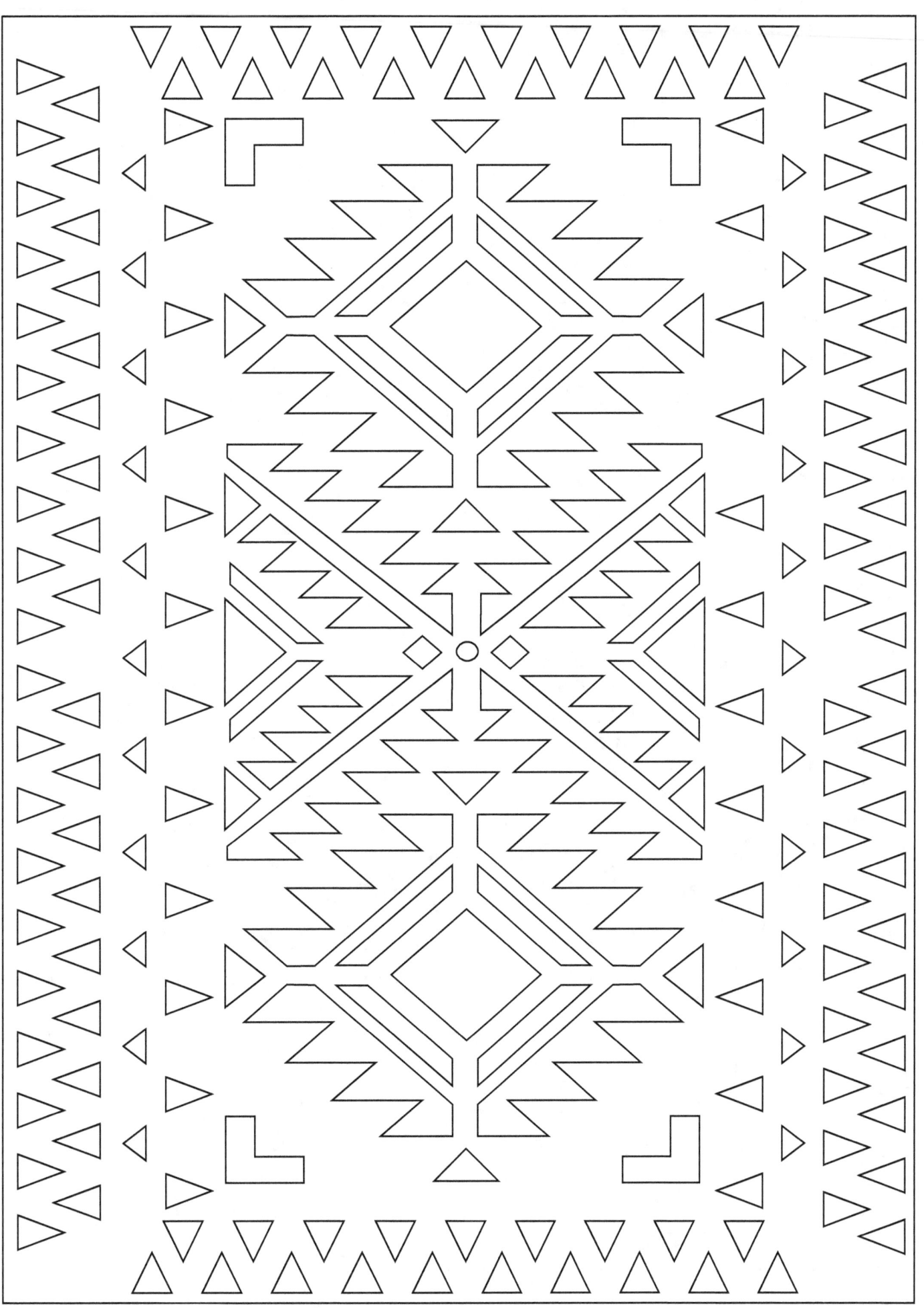

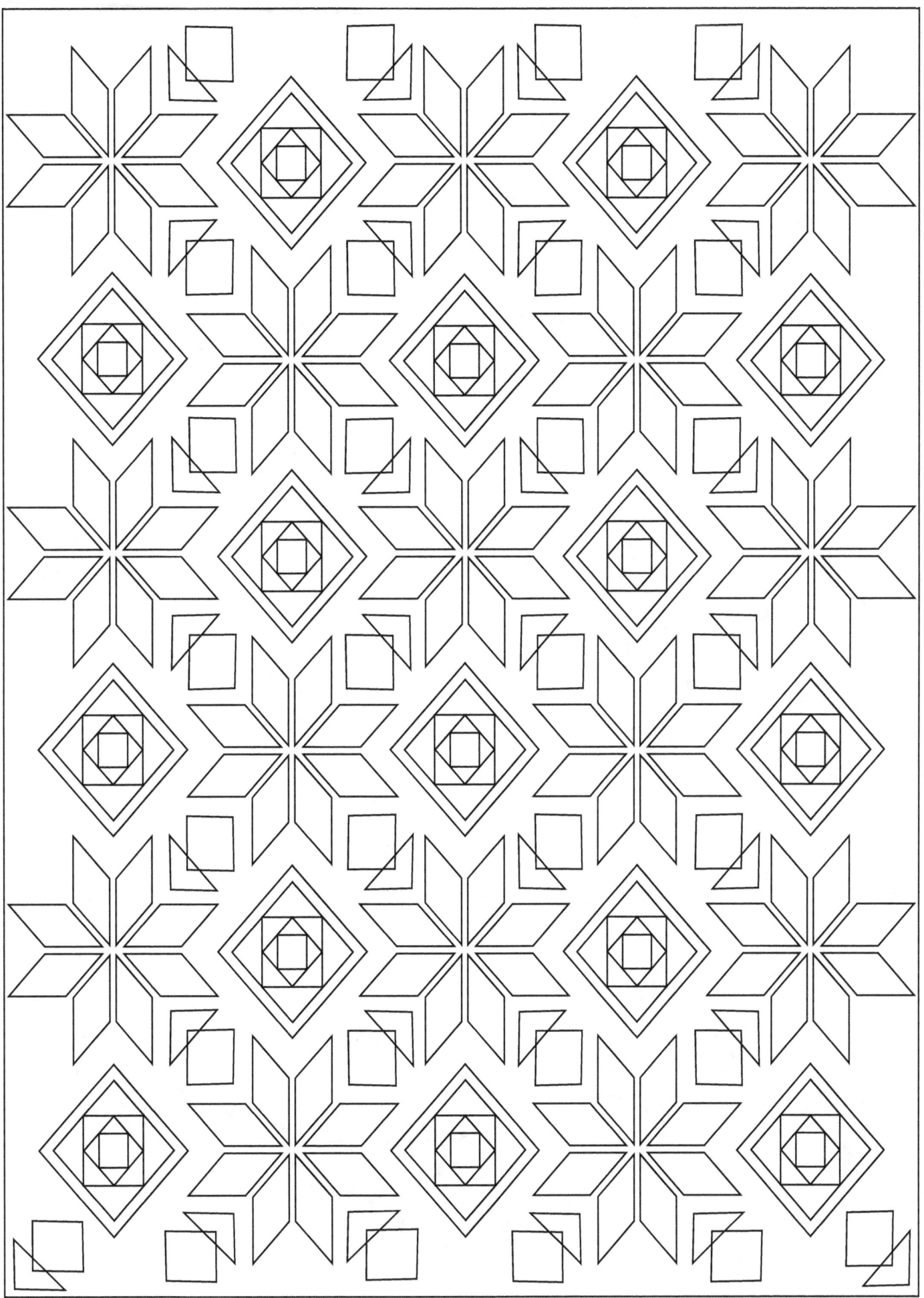

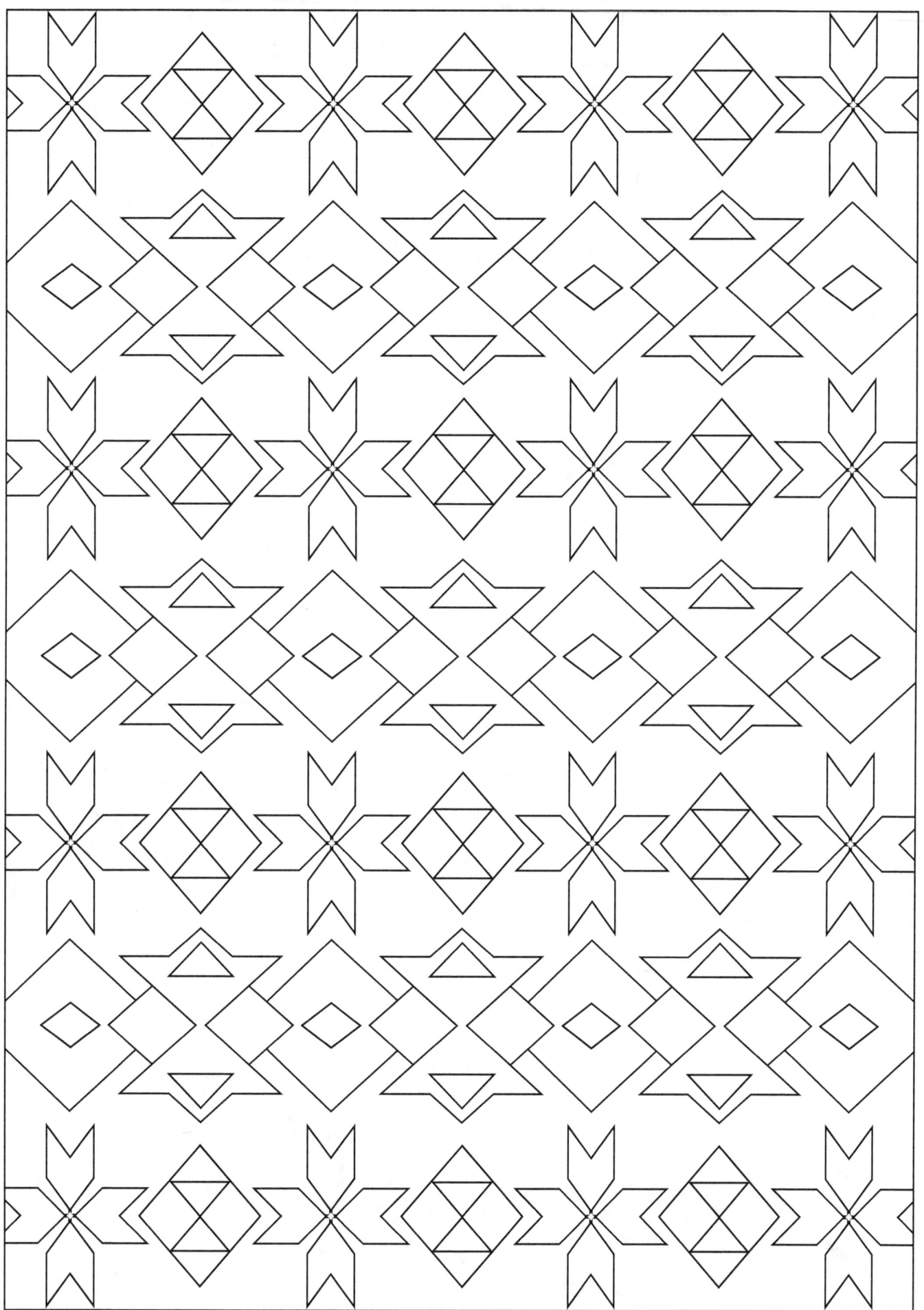

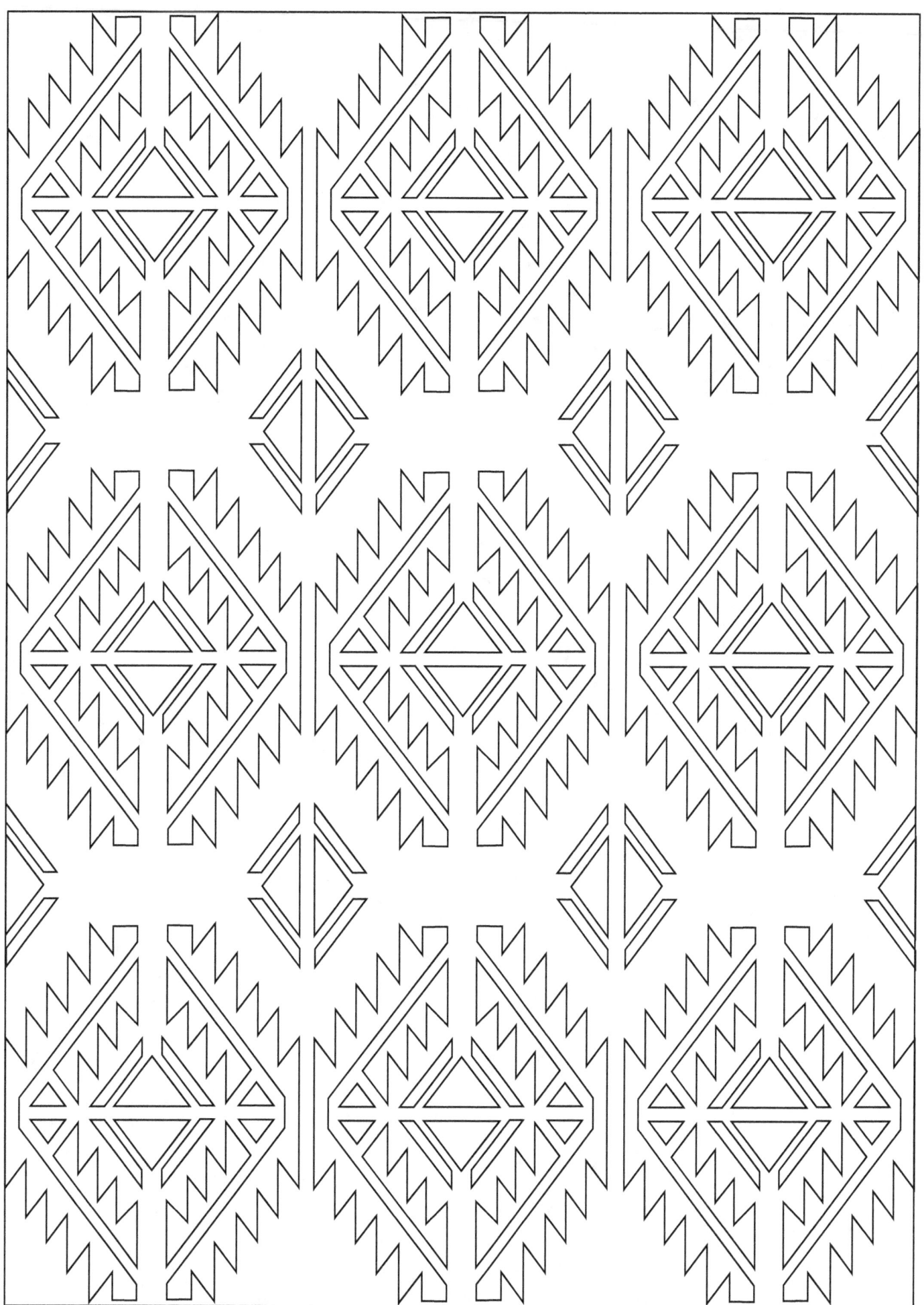

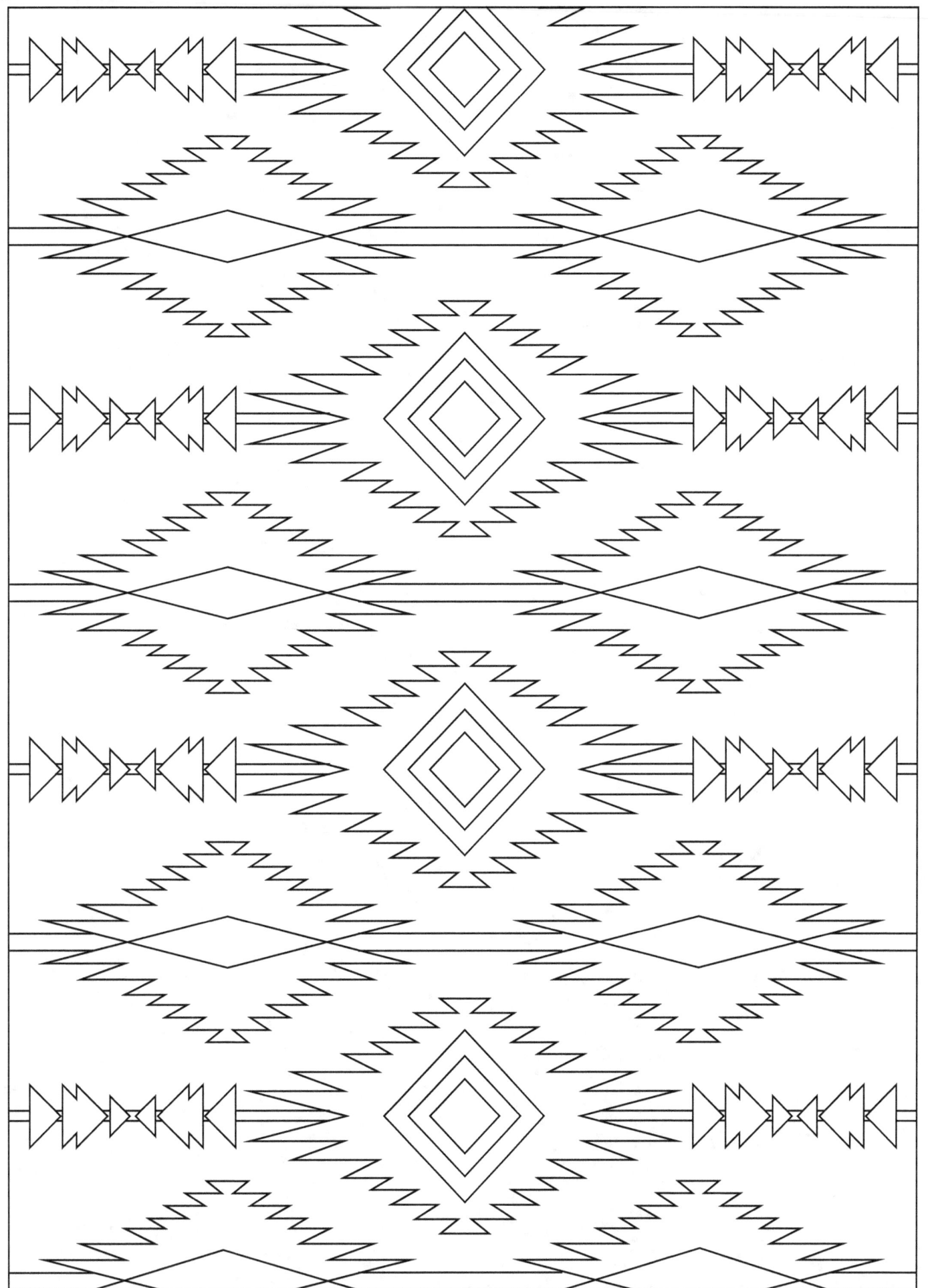

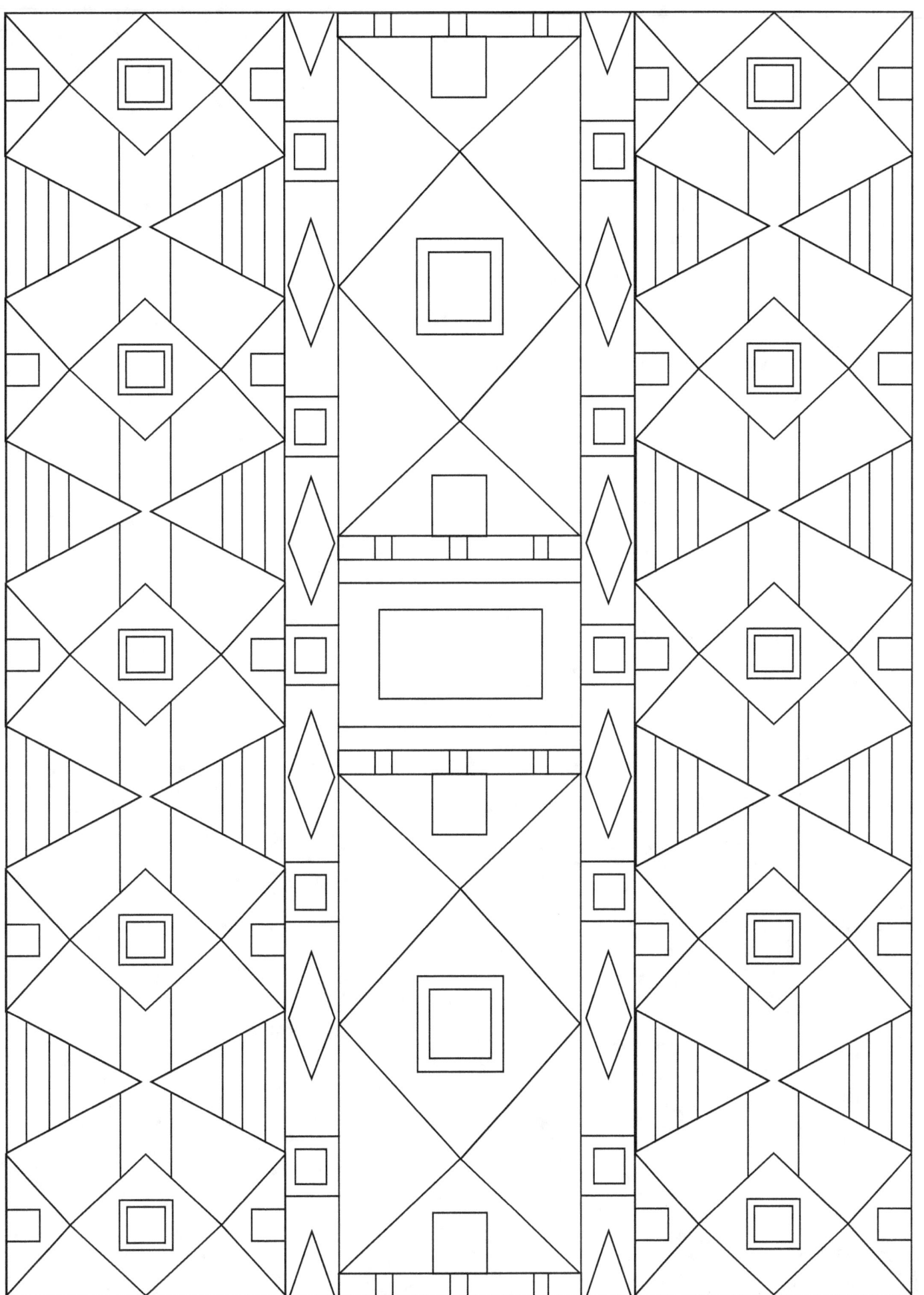